中 央 美 术 学 院

设计学院 学生优秀作品集

视觉传达

中央美术学院设计学院学生优秀作品集·视觉传达

丛书策划　谭　平　颜新元

丛书主编　谭　平　颜新元

本册编著　航　海

编 委 会　吕品晶　江　黎　杭　海　谭　平

整体设计　谭　平

封面设计　孙　聪

版式设计　孙　聪

电脑制作　黄　悦　郝玉刚　高　凌

责任编辑　颜新元

责任校对　敖　群

出版发行　湖南美术出版社

地　　址　长沙市雨花区火焰开发区 4 片

经　　销　湖南省新华书店

制　　版　深圳利丰雅高电分制版有限公司

印　　刷　深圳彩帝印刷实业有限公司

开　　本　850×1168　1/16

印　　张　7.75

2002 年 1 月第 1 版　　2002 年 1 月第 1 次印刷

印　　数　1－4000 册

ISBN7-5356-1605-4/J·1517　定价：56.00 元

视 觉 传 达

序

　　《中央美术学院设计学院学生优秀作品集》是设计专业成立六年来优秀学生作品的集中展示。其教学成果与特色所呈现的既不是一种模式或某种流派的表现，也不是以个别作品的优劣作标准的评价，而是诠释一种以创新的思想和开放的心态办学的教学理念。

　　面对转型期中国经济的迅猛发展所导致的社会需求的急剧变化，中央美术学院的设计教育为顺应社会发展的需要，在教学中将部分课程的设置向应用学科倾斜，这是符合客观规律之举措。然而，鼓励学生在校期间就积极投身经济主战场，抑或坚持教育之根本任务，引导学生以充足时间和精力去了解和掌握最本质最重要的思想知识和方法、探求人类最具普遍意义的和恒久价值的真理与学识，始终是我们关注与探究的问题。

　　人一旦置身于高速行驶的列车中便难以觉察到轨迹的偏离。教育同样需要不断地检测与修正发展的目的与方向。作为人文学科的设计艺术，在大学学习阶段尤为需要纯净的环境，需要与异化的现实社会保持距离。只有这样才能够使我们更清晰地认识社会、坚守真理；才能更清醒地洞察独特的思想所带来的潜在价值，而不只是注重实际的操作与迎合现实的妥协。学生是为思考和学会思考来到这里，我们的教学不仅有义务承传美术学院这一优良的教育思想，更有责任将其发扬、拓展，使之成为现代教育理念的坚实基础。

　　在历史发展的进程中，无论是一个国家、一个民族、一个社会都需要有一个能够超越功利的诱惑，具备批判精神和创新意识的团体，来自觉承担起人类文化传承和创造的伟大使命。

　　丛书所选择的学生作品，大多具有个性化、艺术化和实验性之特征，它充分体现了鼓励与培养学生独立思想的教育宗旨，我们力求使这块教学园地能够成为融会众多不同思想与观念的、教师和学生的教育与自我教育、独立思考的精神家园。

谭　平

中央美术学院设计系主任　教授

前　言

　　学生的作品最能体现一所学院的教学思想与特点。看过许多院校的学生作品集，其中多数都采取课程分类的方式来展示学生的作品，透过有所选择的科目的排列，我们可以感受到一所学院的教学的基本框架，这诚然是一种成熟、有效的编排方式，但这种方式的主要目的是全面展现学院的教学面貌，这种对整体的强调不可避免地在各课程作业的取舍问题上采取折中的态度以求得表面上的平衡；另一个弊病是，虽然书中充满了学生的作品，但你却无法领略到任何一位学生的较为完整的个人风貌。这二点美中不足的瑕疵在我们看来却是难以接受的，于是我们换了一种方式，从本系众多的学生中挑选了二十位学生，这种挑选没有年级人数的比例的考虑，没有课程科目的平衡考虑，唯一的考量标准就是学生的个人天分与整体素质。每个学生的作品来源由各任科教师推荐与个人自选相结合，于是，这个作品集看上去不够系统，更谈不上全面，但"全面、系统"既代表着一种成熟、一种完善，其负面意义是发展的停滞、潜在可能的消失。另一方面，我们的设计教学远未到达写总结报告的时候，事实上我们希望这一时刻永远不会来临。

　　这个作品集并没有试图汇集自设计系成立以来的所有的最好的学生作品，而只是挑选了二十名有特点的学生的不很完整的各科作品做专人介绍，这个看似随意的结集方式的背后有一个严肃的、诚挚的动机：我们希望这本作品集多一点人的体温，少一点浮华的修饰，因为在一个全面讲求包装的时代，人们更希望看到真实、鲜活的东西。

　　区区二十人的作品的汇集，只是阶段性的教学的产物，但透过它们，人们会感受到我们学生的心态、境遇与潜质，同时也必然地会体察出其中的不足与差错，正视错误一直是我们首选的教学态度，儿童心理学家告诉我们，对于儿童而言，出错往往发生在儿童不满现状、试图有所改变的时候，是好事情，这一创造性的描述非常适合我们这个建立不满 6 周年的年轻的设计系——它的教员和学生们。

杭　海

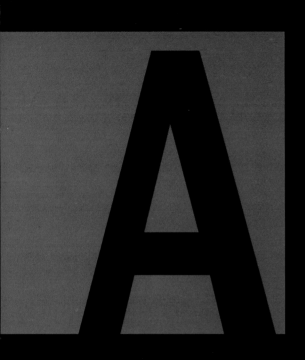

广 煜

1979 年出生于北京市
1994 年考入北京市工艺美术学校
1998 年考入中央美术学院设计系

Green
Production

R·O·O·M
BACK 2 NATURAL

the Sound of

let go

the beautiful

TOGETH

B

庄春青

1977年2月18日出生
1996年毕业于中央美术学院设计系获学士学位
现为北京工艺美术学校平面部教师

有一种东西，
只要尝过一次，
就终生成瘾。

有一种刺激，
只要尝过一次，
就永难磨灭。

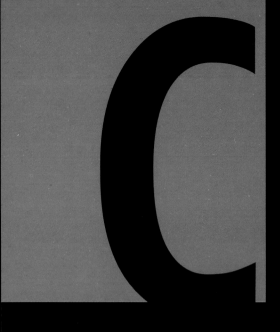

赵 宇

1979 年出生于河北省石家庄市

1994 年考入中央美术学院附中

1998 年考入中央美术学院设计系

2000 年作品《接进来》系列获 " 第九届台湾中国时报广告金 悦奖 " 入选奖。

作品《net+bar》获清华大学建筑学院 2000 年度 " 水晶石杯 " 学生建筑设计竞赛二等奖。

from MEZZANINE
(teardrop)
massive attack

●虚拟的:
If the microformed electrical products devetop into correcting with the
body nervous system,we would connect body with Internet,
and then we all become cyborg.To the cyborg,the limit between
interion and exterior blurs and thedifference between others
and self will be reconstructed.
When the body bound and nervous system bound become dim.
The philosophers has to take the soul/body problem as soul/net
problem and redefine it.
Once we breakthrouth the limit of skin with this method,
so dose the constructure.Some electrical organ will be planted into the
environment."Living" has a new meaning:
it will not be paid muchattention that body lives in the exact
space in terms of constructure,instead,it will be paid much
attention to connectthe nervous system with nearby electrical server,
to make the rooms and person a whole.

Sex love is the important part during the mankind
exchange and it a dispansable
part in mankind multiplication.
Thro h the closest exchange means between peuple,
but it must finish when the
two sides are in the same space.

●虚拟的
Net has all the condition which the traditional sex need,when the transinit speed arrives to a specific demand,
computer could mock all the vision,hearing and sense of touch.When AIDS spreads all over the realistic world,
internet virus invades your host at faster speed.Their sole difference is that they breakthrough the limit of space.
Without the concept of place,this closest exchange means maybe rewritten.

If you go into an a
you will experienc
But in fact your m
The cyber space v
computers almost
of muscle movement
Except the simple
other muscle mov
So physical and se

The muscles stretch out and draw back,
it is the sole means to
produce body movement,
and may be the tool to
help man kind change time and space.
When you move from one space
to another use,
whether it will succede
depends on whether
the muscles move in a right or wrong wa
At this time,
physical and sense movement synchron

and could not dispatch.

When you pick up the telephone,do you imagine that the speaker may be in the
●虚拟的:
拿起电话的同时，有没有想像过电话的那头，或者收音机里的音乐时，
another side of the earth.When you listen to the music in the radio,
你会发现根本不存在一个演出场所的概念，此时你的身体构成已经改变。
you will find that a performing place doesn't exist at all.At this time your body
身体中存在着数种语言和听觉器官，它们不在原初的地点和时间——
constructure changes.Your body has sevtral languages and aural organs which do
这些方式远离城市节奏。
not exist in the original places and time---and they dislocate from the city rhythm.
在虚拟空间里，赛博格生活在一个声音的世界里，没有谁能够被看见，
In the cyber space,cyborg lives well in a sound world in which nobody could be seem,
以无须舞台和观众的方式进行表演，身体之间的对话也四下弥漫。
and could perform without stage or alidience and talks between bodies.
所以我们无须在城市地图上四处寻找碰面地点。
So we don't need to meet searthing in the city map.

● 传统的:
You sit in a bar,drinking and listening to the band.This is a familiar and traditional scene
身处一个酒吧，一边喝着啤酒，一边听着乐队演奏，这是一个熟悉
the musicians and listeners are in a public space,In the scope in which both could hear,
传统的场面，乐人与听众间处于一个公共空间，在彼此的听力所及的
music pulls the two sides into a kind of face-to-face relationship.
音乐把双方拉进一种面对面的同步的关系中，双方在某个特定的时
The two sides exchange in a specific place at a specific time.This is the traditional con
特定的地点以声音进行交流，这便是传统的交往方式。

● 传统的:
Most work has to be done by hand.Man has to be in the wo
大多数的工作都是由双手的活动来完成的。人必须身处工作的空间
People transmit information express ideas and understan
在人与人之间，是通过握手、拉手、玩搂、打击之类的触觉感受来
each other through handshaking,touching and beating,etc
表达感情，达到互相沟通的目的。

In the cyber space,hand may be the important organ which
在电子化空间中，手也许是人体与网络连接的重要器官，
connects body and net.It could send information to the outside
它能向外界传递出信息，也能够靠触觉来接受信息。
world and receive information by sens of touch.When he works,
在他工作的时候，可以靠着远在千里之外，
the worker could finish through a powerful feedback device and
一个强有力的反馈装置和一只电子手完成工作。
a electricalhand far away.
如果工作可以在家中完成，这便使得家与办公室两个
If the work could be done at home,
不同的空间相混淆了。
the different space of home and office confuses.
而当你伸展开时，伸手之处将没有极限，没有固定尺寸。
And when you strech out,
there is no limit,no set size.

With the coming of internet,Time and the development of internet technology,the
网络时代的到来以及网络科技的发展，使得有关空间、
个人身份和主体性的概念将被改写。21世纪的建筑和城
uncepts of space, identity and subject will be rewritten.The architects and city planne
市规划者们必须着手为计算机中的人体建造新的理论框架。
of 21 century have to establish new theorical frame for the body in the space

In the cyber space, the sole centre of city has been changed.
网络虽然具备计算机节点和放射状的
Although networking has the definite structure which
传输线路所构成的明确的结构，并可以绘制
Each server is a district centre, which is connected through:
up of computer knots and radioactive transmission line,
出级复杂的图纸，但从根本上说它是及空间
information hightway and the traditional metropolis concept
can draw very complicated graphs. However, basically,it is a
perishes step by step.The mankind live in the fiber optic cable:
的。它没有具体的形状和面积可以描述，它
The networking has no specific shape and area to
在电子化空间中（cyber-space），城市的单一中心化被改变了，
It spreads over everywhere and doesn't exist in a spec
in which the spirit space is flexible and the object is changable.
却可以同时出现在每一个地方，
每一个服务器都是一个社区中心，之间由信息高速公路相连，而传
but may appear in every place at the s
The bound between people is redetermined, too.
统的都市概念渐渐淡灭了，人类寄生于光缆之中，精神的空间可自
Internet eliminates the traditional scale which could identify t
Because the limit is blured,space could not be determined,
由伸展，所有事物变得具有可改变性，人与人的界限也被重新定义，
citizen clearly.In the ordinary city structure,your place genera
空间因界限模糊而无法界定，城市无中心，建筑完全被解构，这种
在普通的城市空间格局中，你的处所，通常表明你
The instability and blur of space also pounds the traditional society limit
shows your identify and the identity generally determine whic
空间使用的不稳定性和模糊性也冲击着传统的社会边界。在城市这
you could exist.The traditional space has its specific meaning
On the level of the city, recognizable, irrelevant physical
传统的空间都有自己特定的意义：公寓、购物中
一层面上，通过规定容积率的，互不相干的物理区域制造着鲜明
apartment,shopping center,entertainment place,hotel,gaybar
area makes vivid society difference.
心、娱乐场所、酒店、同性恋酒吧、贫民区、监狱
sleem,prison. However, networking takes the exchange
But when the use ofconstructure space will not get the eternal allocation while rely on the software
然而，网络对交流空间予以分解，摧毁了地理
and data every minute,the classification is not specific and need to redefined. The traditional
space into parts,destroys the concept of geographic position
The simplest fictitious time and space is eye and TV.
constructure type and modle tend to collapse pounded by the cyber.At the same time the construction
位置这一观念，它并不存在哪一个地址更好的问题。
● 虚拟的:
最简单的虚拟时空，便是眼睛与电视机。
reorganization will have deep meaning. The construction and its constituent parts not only need to
So it is not a problem which position is better
摄像机的电子视网膜可以制造更诀与断裂，
不仅需要与自然和都市环境相协调，而且必须与电脑化环境相适应，
The electrical retina of video camera could make
adapt to nature and metropolis but also adapt to the computerized conditions.They must more and
我们透过显示器看到的景色经过了
它们须越来越多地充当网络界面。最终，建筑会变成计算机界面，
altternate and split.
more act as cyber interface.at last constructure will become computer interface and computerinterface will become constructure.
重新定义，传统建筑类型和模式受到电子的冲击而趋于互融。
The scene we see through takes place in distance.
计算机界面也会变成建筑。
随之出现的建筑重组将具有深刻的思想意义。建筑物及其组成部分
倘若并且发生在远远的地方，
After reducing or amplifying,
we've got the rebroadcast.If you are in
如果处在六个方向显示的房间中，
a room with display in six direction,
你能定义你是身处现实或者虚拟的世界吗？
could you determine whether you are living in
倘若将双向的永不关闭的电子窗口，
a realistic or fictitious world?
放置在两地之间，
If you place two-direction and never-stop
你就创造了把两者连接起来的中介空间，
electrical windows between two places,
而人就身处这样的空间。
you create the medium space which connects the two
constructure and you will live in such a space.

To the man in the realistic world,
对于现实世界中的人来说，
time and space is continuous,
赖以生存的时空是连续的，
man sees the world by eyes,
人们通过眼睛看见现实的世界，
while vision arises by light with all
而视觉只是靠光和不同波长的
kinds of waves projecting on the retina.
光线在视网膜上投影来产生。

刘 宓

1977年生于北京，曾就读于中央工艺美术学院附中
中央美术学院附中，中央美术学院设计系

像很多大型动物一样
大象很欢迎专食昆虫的小鸟
没有鸟的帮助
它很难摆脱成群昆虫带来的困扰
越是庞大的结构
越需要细致入微的料理

*刘宏身高 1522毫米

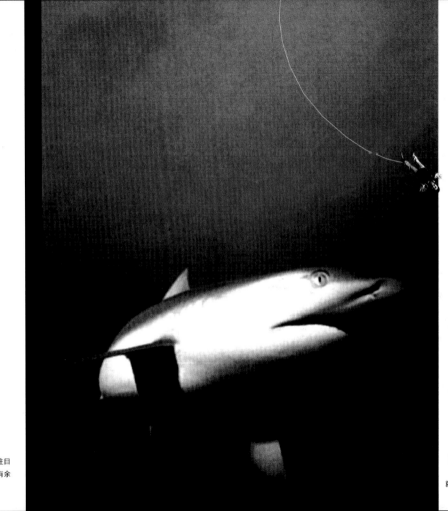

漏网之鱼

一网打尽了吗
一举一动虽不引人注目
关键时刻却能游刃有余

*对应身高 1522毫米

小也有诱惑力

想钓大鱼
你的诱饵并不需要太大
面对庞大的对象
小诱饵能投其所好
依靠特有的动态
色彩 气味及别的本领
它可以具有强大的吸引力
有诱惑力
就能以最小的代价钓到大鱼

*对应身高 1522毫米

Love is here

Love

Love

胡晓媛

1977 年 12 月 8 日生于哈尔滨
1994 年 9 月考入中央美术学院附中
1996 年 作品《九件》获吴作人基金会优秀习作奖
1998 年 9 月考入中央美术学院设计系至今
1999 年 作品《禁锢》入选《新艺术后援——70 年代后》作品集

Aubrey's Excursions Beyond the Call of Duty The Remix Project

brey's Excursions Beyond the Call of Duty

Auntie Aubrey's Excursions Beyond the Call of Duty The Orb Remix Project

Auntie Aubrey's Excursions Beyond the Call of Duty The Orb Remix Project

The Or

Auntie Aubrey's Excursions Beyond the Call of Duty

Here...... You want !

cosmetics store

妆品店

0-69329115　Fax: 8610-69329115　Tel: 8610-69329115　Fax: 8610-69329115 ·

MOON FLIGHT

What we have seen is not what we are seeing.
What we are seeing is not what we are willing.
What we are willing... is not...

—ZHA...

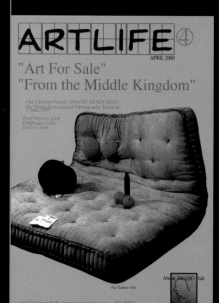

ARTLIFE ④

APRIL 2000

"Art For Sale"
"From the Middle Kingdom"

Our Chinese Friend -ZHANG XIAO GANG
The Ninth International Photography Biennial
China, 1998

Zeer79pyvier gl±ñ
Gihhhausx ryxer
Jcotlev's dolk

An Nanow titt

About ZHANG Dali

>>>I find myself disappearing in the process. -XU ZHEN

ARTLIFE ④

"Art For Sale"
"From the Middle Kingdom"

王 艳

1979年出生于辽宁省大连市

1997年考入中央美术学院平面设计专业

观念书籍设计《福尔摩斯探案集》曾获 "第五届书籍装帧艺术展探索奖"，作品曾首在北京中国美术馆、桂林及昆明等地展出

作品《展望2000》获 "惠普杯大赛" 入围奖

《饕餮美餐》曾获金牒奖北京地区入围奖

别人说我声音小 不出众 像只蚊子 但我的成功几率却让你无法统计

别人说我声音小 不出众 像只蚊子 但我的力量却让你无

I + I

未来的書的未来

未来的

書的未来

现代人的物质生活比近代人略显单调,
类的根本需要来设定的.

，这是完全根据人

刘 涛

1976 年出生于山西太原
1996 年考入中央美术学院
2000 年毕业于中央美术学院获学士学位

POSTER

Poster
&paper
Print

POSTER

Poster is organ
communicate

Poster is
space of contrad-
ictory
exchange
interaction

POSTER

陈 礼

1973 年出生于湖南

考入中央美术学院设计系

2001 年毕业于中央美术学院获学士学位

K

陈晓犇

1979 年出生于山西太原
1995 年考入中央美术学院附中
1999 年考入中央美术学院设计系
2001 年作品获首届中国平面设计大赛优秀奖

时间

重量

浓度

电压

进度

五十分音符

"伍"

站牌

门牌

The Central
academy of Fine Arts
Design Dept.

100015

197 9cx@sina.com

95950-2636 550

64319589

chenenxi

chen

新浪首页 - Microsoft Internet Explorer 由 PINK Technology LTD 提供 - IE版

文件(F) 编辑(E) 查看(V) 转到(G) 收藏(A) 帮助(H)

停止 刷新 主页 搜索 收藏 历史 频道 全屏 邮件 字体 打印

地址

确定 取消

chenxi

http://ad.cn.doubleclick.net/click.10K

Internet 区域

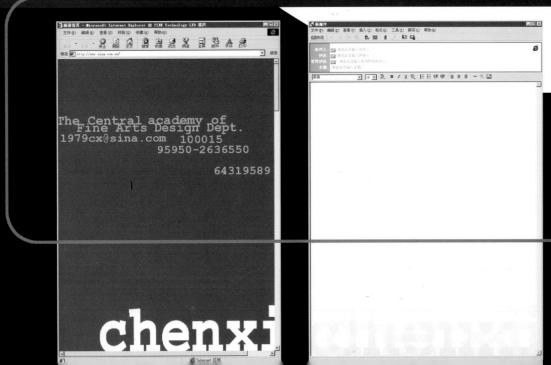

The Central academy of
Fine Arts Design Dept.
1979cx@sina.com 100015
 95950-2636550

 64319589

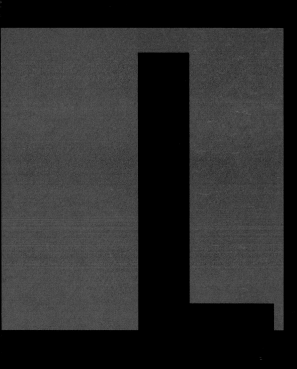

徐光东

1973年出生于辽宁省抚顺市

1993年毕业于抚顺艺专美术专业

1999年毕业于中央美术学院设计系获学士学位

现任教于北京市工艺美术学校平面设计专业

同时任职金马广告有限公司·北京分公司创作总监

道：阿呀！娘子，大官人又不是別人，沒事相陪吃 盞完，怕怎的！ 婦人口裏說 不用了 坐着卻不動身。婆子一面把門拽上
在屋裏。當路坐了，一頭鎖着鎖。
婆去了，倒把椅兒扯開一遭坐着，卻衹偷眼瞧看，西門慶坐在對面，一徑把那雙涎瞪瞪的眼睛看着他，便又問道："卻才到忘了問
帶笑的回道："姓武。" 慶故做不聽得，説道："姓堵？"那婦人卻把頭又別轉着，笑 道："你耳朵又不聾。"西門
姓武。衹是俺清河縣 夫 衹是縣前一個賣炊餅的三寸丁姓武，叫做武大郎，敢 婦人聽得此言，便把臉
"便是奴的丈夫。 不做聲，呆了臉，假意失聲道：你又沒 低聲説道："你又没
慶道："我替娘子 裏娘子長娘子短，衹顧白嚼。這婦人一面筝 拈着衫袖口兒，咬得
斜溜他一眼兒 上面緑紗褙子道："央煩娘子替我搭的幹 小人偏要自己安放。
着袖兒別轉着，卻也是姻緣湊着，那衹箸兒剛落在金蓮裙 婦人，婦人笑着不理
些，讓他吃菜兒。

一面低着頭，把腸 是你的箸兒！"西門慶聽説，走過金蓮這 下身去，且不拾箸
。那婦人笑將起來 我要叫了起來哩！"西門慶便雙膝跪下説 一面説着，一面便
"你這歪斯纏人， 些！"西門慶笑道："娘子打死了小人，也得個 抱到王婆床炕上，
這婦人自從與張大戶 人如鼻涕膿如醤的一件東西，幾時得個爽利！就是嫁了 想，三寸丁的物事，能有
風月久慣，本事高強的 弄？ 但見：
并頭鸞穿花。喜孜孜連理投生，美甘甘同心結綹。一個將朱唇緊貼，一個將粉臉斜偎。羅襪高挑，肩膊上露兩彎新月；金釵斜
海盟山，搏弄得千般旖妮；羞雲怯雨，揉搓的萬種妖嬈。恰恰鶯聲，不離耳畔。津津甜唾，笑吐舌尖。楊柳腰脉脉春濃，櫻桃口佛
流香玉顆；酥胸蕩漾，涓涓露滴牡丹心。直饒匹配眷姻諧，真個偷情滋味美。

才罷，正欲各整衣襟，衹見王婆推開房門入來，大驚小怪，拍手打掌，低低説道："你兩個做得好事！"西門慶和那婦人都吃了
子呀，好呀！我請你來做衣裳，不曾交你偷漢子！你家武大郎知，須連累我。不若我先去對武大説去。"回身便走。那婦人慌的
氏 聲："幹娘饒恕！"王婆便道： 你們都要 依我一件事，從今日爲始，瞞着武 大官人的意。早叫你早來
一日不來，我便就對你武大説。"那婦人羞得要不的，一説不出來。王婆催道："卻是怎的 地回覆我。"婦人藏轉着頭， 西門
又道："西門大官人， 人留下件表記拿着，才見真情。"西門慶便向頭 也要對武大説。"西門
婆子道："你每二 卻被王婆扯着袖子一掏，却去了一條杭州白 來。三人又吃了杯酒 西門慶道："好
大看見生疑。 慶，蹬過後門歸來。先去下了簾子，武大 幹娘，真好手段 唱姐兒出身，甚且
你兩個生扭做 東些來！西門慶道："色系子女不可 眼望旌捷旗，
棺材出了討挽 看街上無人，帶上眼紗去了。不在話 西門慶便向袖中取出一錠十兩銀子來，遞 才能動人意。那婆
家討茶吃。王 多謝大官人布施！"因向西門慶道： 身往她家推借瓢
天喜地收了，又 因向婦人使手勢，婦人就知西門慶來了。婆 忙迎將出來道：
人家裏坐。"婆子道： 我往你王奶家坐一坐就來。若是你多來時 若不聽我説，打下你個
換了一套艷色新衣 只看家，我往你王奶家坐一坐就來。

王婆茶坊裏來。正是：
笑，心裏原來別有仁。有詞單道這雙關二意： 這瓢是瓢，口兒小身子兒大。你幼在春風棚上悬兒高，到大來人難要。他"

...怎樣煉成的

荷馬史詩

紅樓夢

王雪皎

1978 年出生于大连

1997 年考入中央美术学院设计系

2000 年获北京 2008 奥运会申办委员会徽设计优秀奖

2000 年获香港刚古纸 VI 形象设计大赛北京区域奖

2001 年获靳埭强平面设计基金奖优异奖

2001 年招帖入选日本富山第六届国际招贴三年展

2001 年毕业于中央美术学院获学士学位

感觉是天生的

butterfl

产品设计 · · · · · · · · · · · · · · · · · · ·

产品设计

梁远苇

1977 年出生于北京

1995 年毕业于中国科技大学附中

1999 毕业于中央美术学院设计系获学士学位

2000 年就职于北京正邦文化艺术发展有限责任公司任艺术总监

我不够完美

I'm an egg, I'm not complete

我不够坚硬

I'm an egg,I'm not tough

我不够强壮

I'm an egg,I'm not stiff

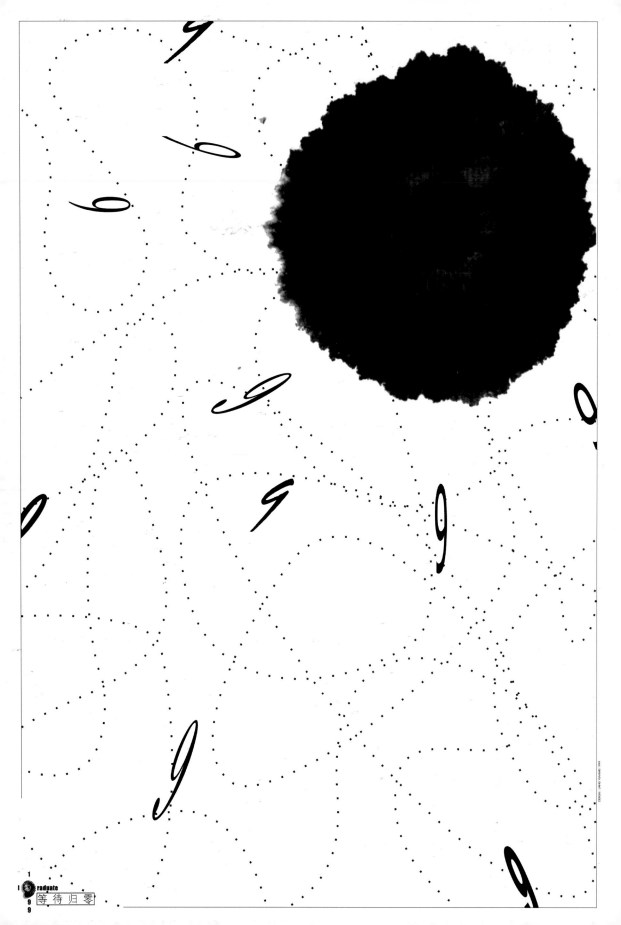

I ♥ graduate
等待归零

1
9
9

渴望完满

i
Graduate
1
9
9
9

吴苗苗

1976 年出生于四川重庆
1997 年考入中央美术学院设计系
2001 年毕业于中央美术学院获艺术学士学位